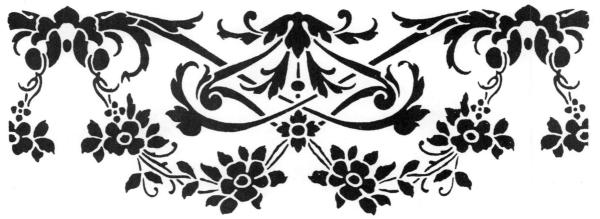

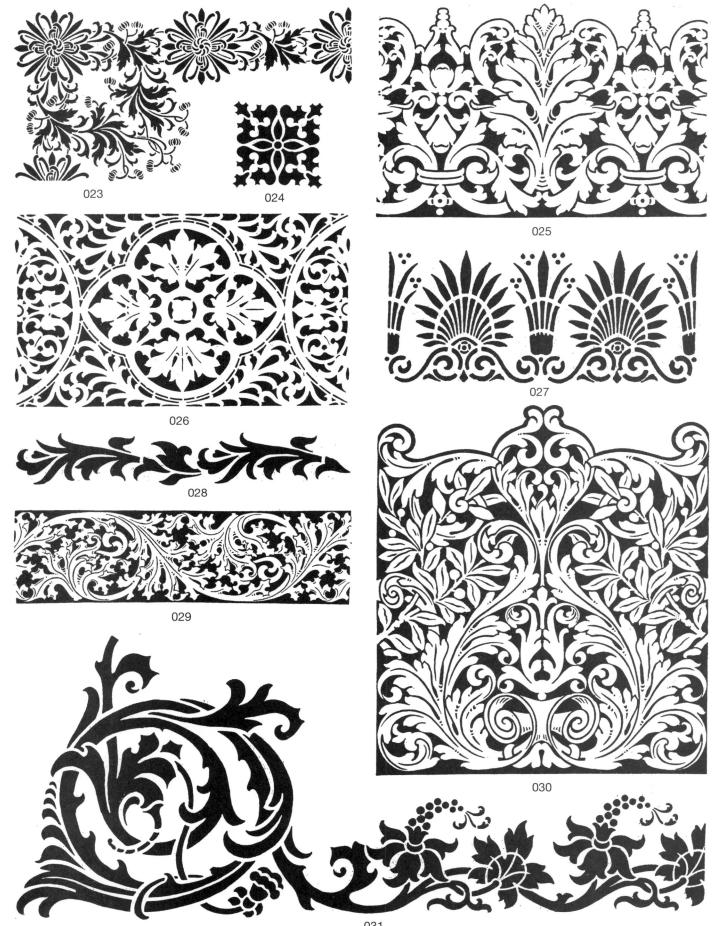

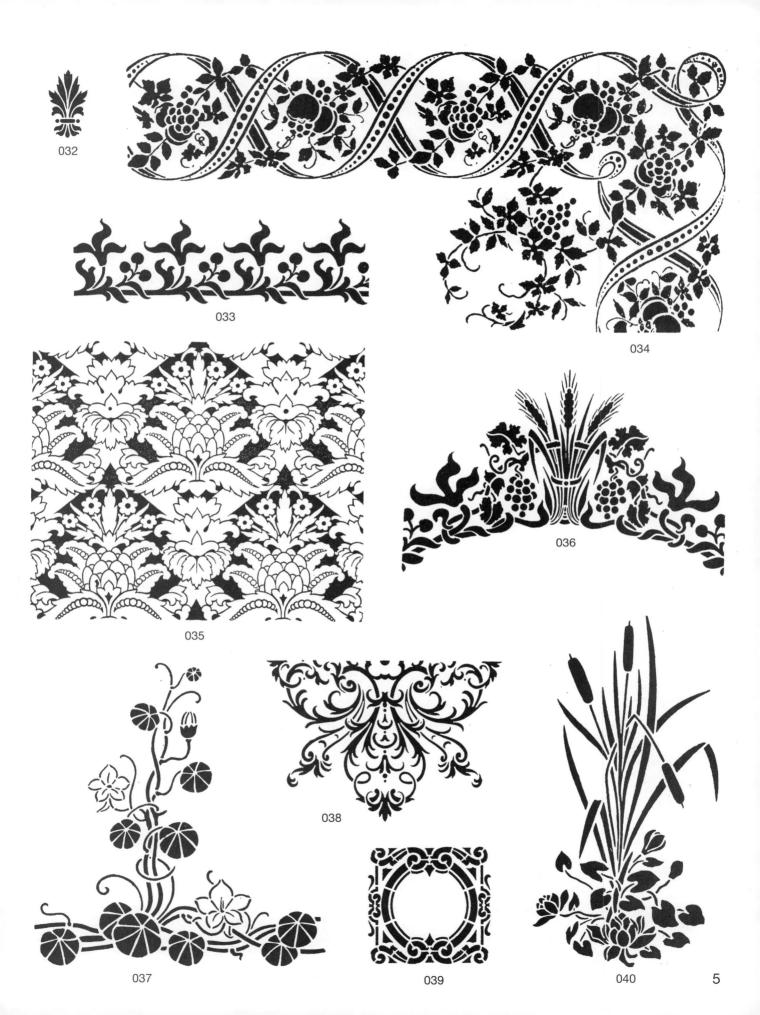

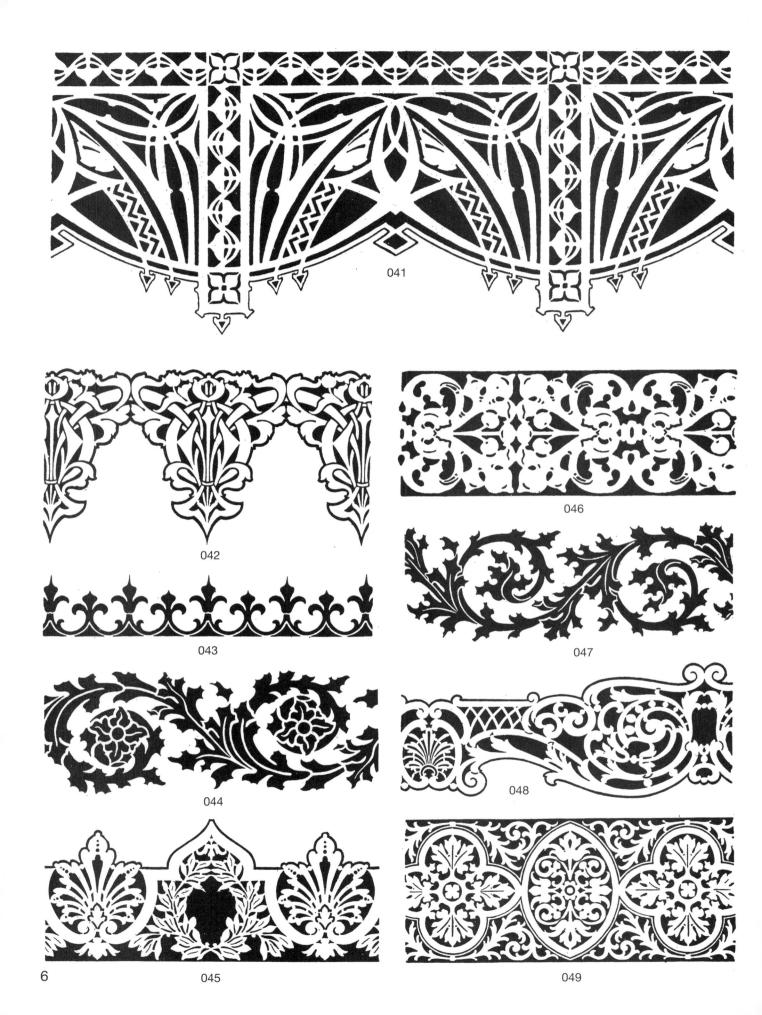

THING THE STANTARY

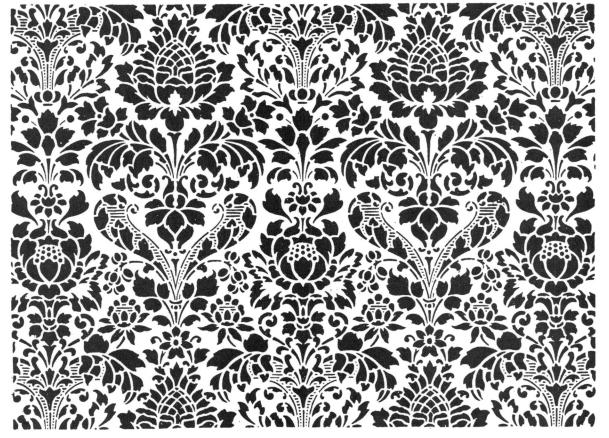

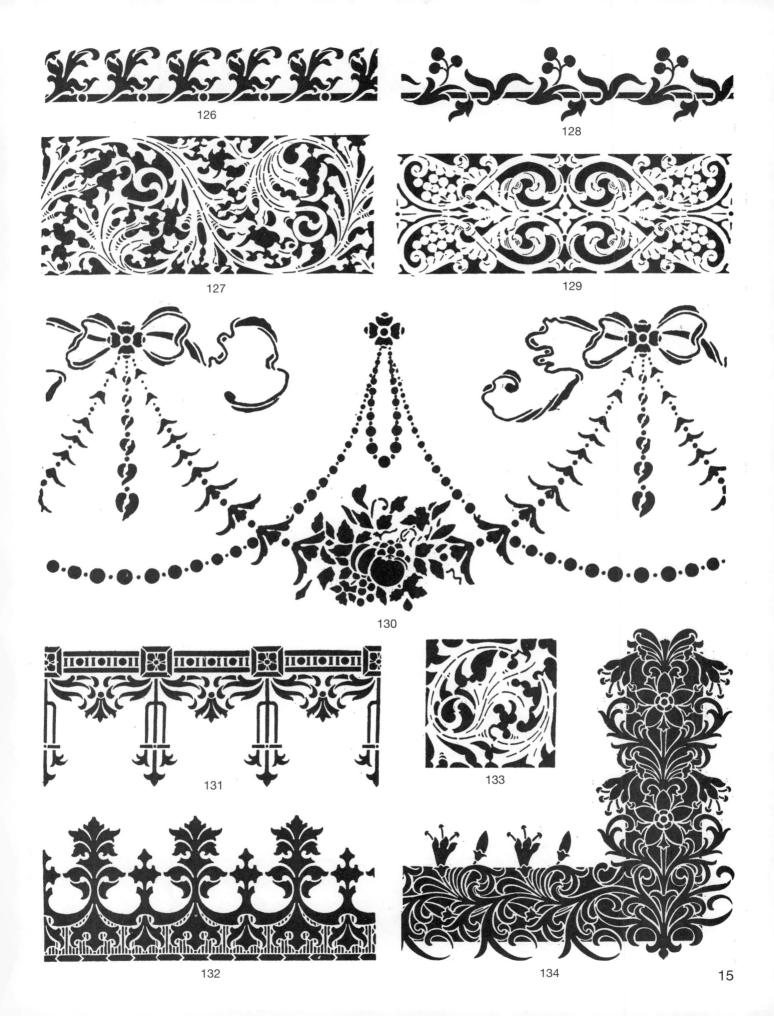

-

WANTER TO THE RESIDENCE OF THE PARTY OF THE

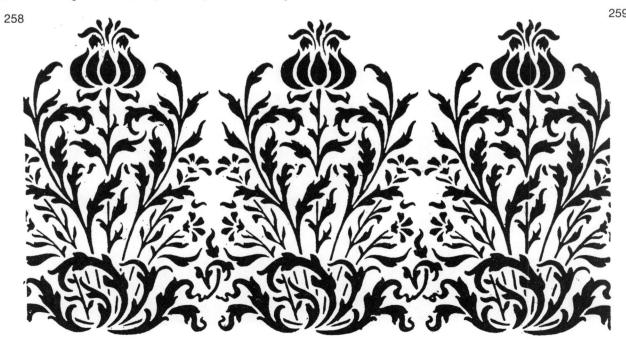

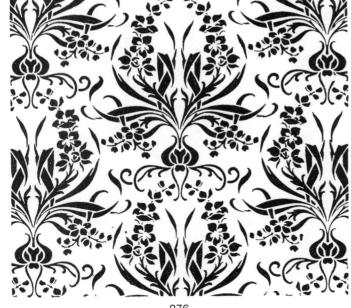

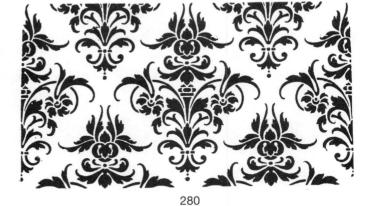

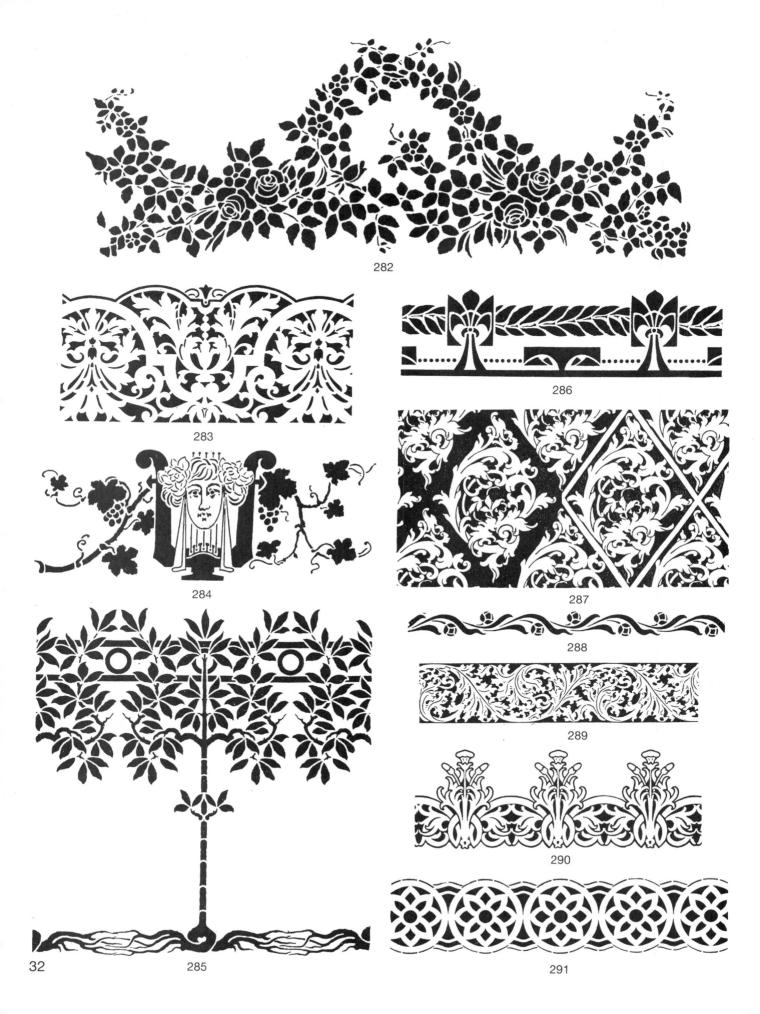

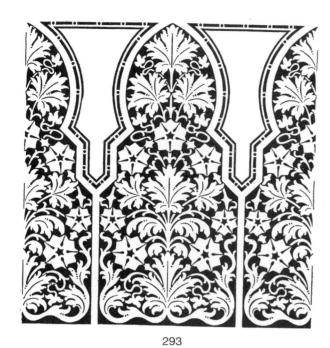

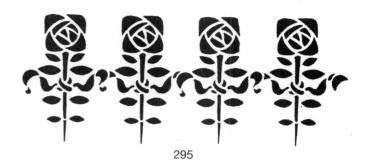

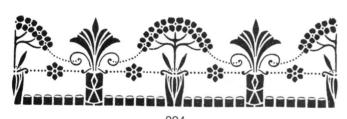

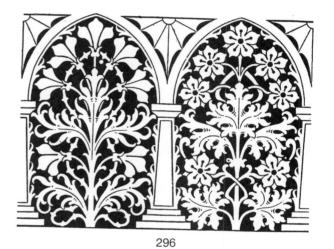

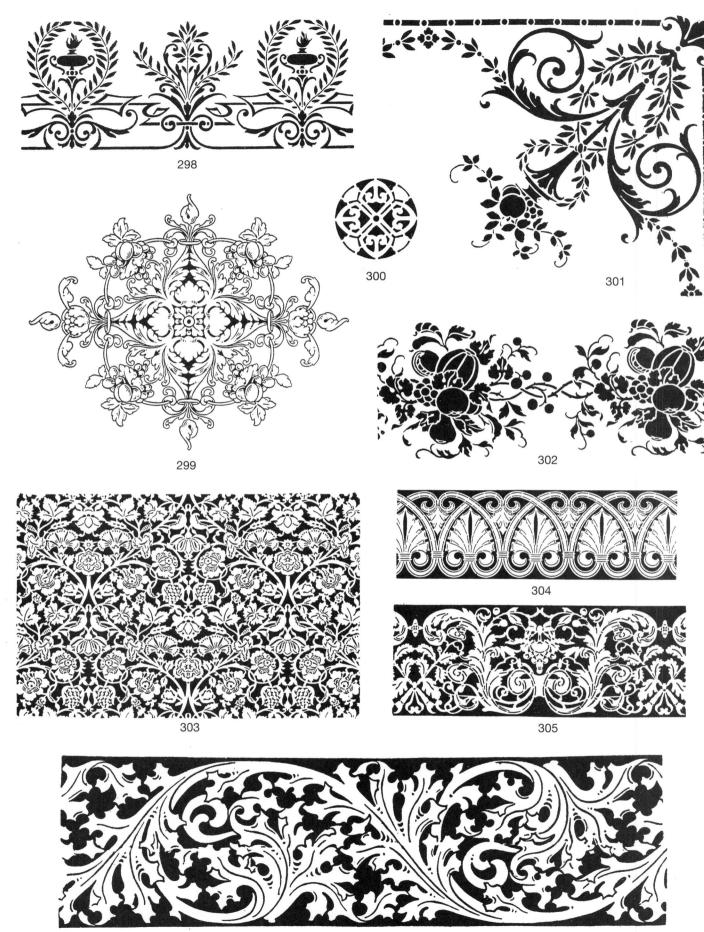

##